DOUBLE EXPOSURE

CIVIL RIGHTS AND
THE PROMISE OF EQUALITY

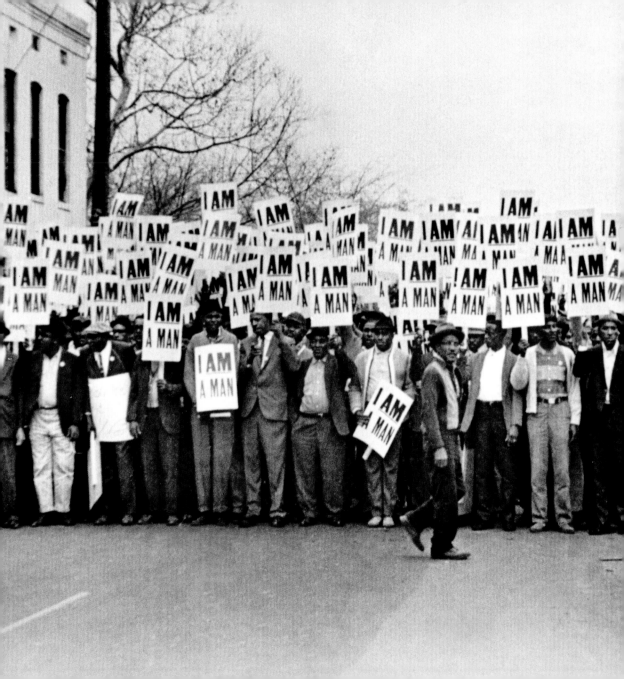

DOUBLE EXPOSURE

CIVIL RIGHTS AND
THE PROMISE OF EQUALITY

Photographs from the National Museum of
African American History and Culture

Smithsonian
National Museum of African American
History and Culture

Earl W. and Amanda Stafford
Center for African American Media Arts

GILES

National Museum of African American History and Culture
Smithsonian Institution, Washington, D.C., in association with D Giles Limited, London

For the National Museum of African American History and Culture
Series Editors: Laura Coyle and Michèle Gates Moresi

Curator and Head of the Earl W. and Amanda Stafford Center for African American Media Arts: Rhea L. Combs

Publication Committee: Aaron Bryant, Rhea L. Combs, Laura Coyle, Michèle Gates Moresi, and Jacquelyn Days Serwer

For D Giles Limited
Copyedited and proofread by Jodi Simpson

Designed by Alfonso Iacurci and Helen McFarland

Produced by GILES, an imprint of D Giles Limited, London

Bound and printed in China

First published in 2015 by
GILES
An imprint of D Giles Limited
4 Crescent Stables
139 Upper Richmond Road
London
SW15 2TN
www.gilesltd.com

All measurements are in inches and centimeters; height precedes width precedes depth.

Photograph titles: Where a photographer has designated a title for his/her photograph, this title is shown in italics. All other titles are descriptive, and are not italicized.

Front cover: *Two Minute Warning*, 1965; printed 1995 (detail), Spider Martin
Back cover: *This Is History*, October 16, 1995, From the series One Million Strong, Roderick Terry
Frontispiece: *Sanitation Workers Assemble in front of Clayborn Temple for a Solidarity March. Memphis, Tennessee*, March 28, 1968 (detail), Ernest C. Withers
Page 6: *First Day of Memphis Integration, Tennessee*, 1961 (detail), Ernest C. Withers

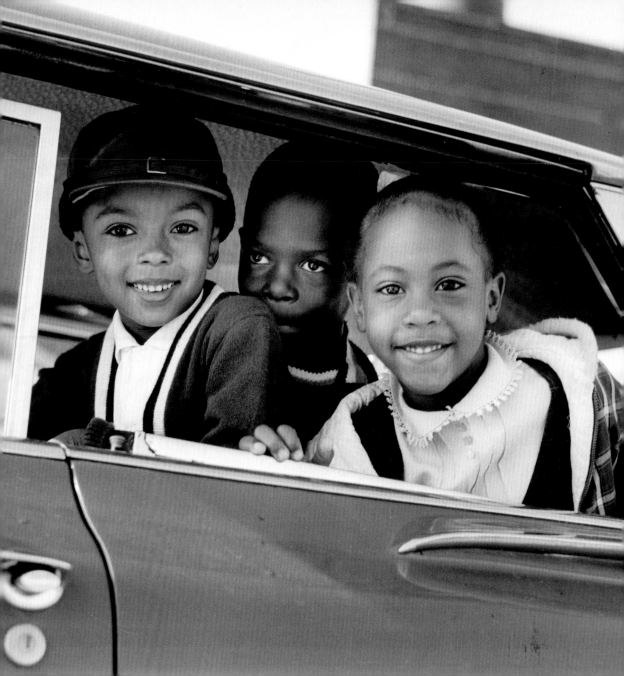

Foreword

America's Civil Rights Movement looms large in the popular imagination. Photographs and film footage recall the tense moments, the violence, and the courage of those who marched, rode buses, and protested to demand basic rights of citizenship and social justice. As a museum of the twenty-first century, the National Museum of African American History and Culture (NMAAHC) has begun to collect documentation of the mid-twentieth-century events and experiences that have inspired subsequent generations and communities of people around the world.

Civil Rights and the Promise of Equality is the second book in a series of publications, *Double Exposure*, that draws on the Museum's growing photography collection of over 15,000 images. These images also support our innovative Earl W. and Amanda Stafford Center for African American Media Arts (CAAMA), which, as a physical and virtual resource within NMAAHC, exemplifies the Museum's dedication to preserving the legacies of black history and culture.

The Museum's photography collection contains more than 400 photographs reflecting the Civil Rights Movement. They include images of police dogs and water hoses directed at protesters in the early and mid-1960s—images that dominated the media, shocking America and the world. Yet the selection of nearly 60 photographs in this book is a mere glimpse into the variety of experiences that characterizes this era. The excitement, joy, and hope of change was made possible not only by active protest, but also by the quiet, steadfast actions of many individuals: the elderly woman who registered to vote for the first time; the youth who attended a newly desegregated school; the parents who sent their sons and daughters to college, and then agonized over their participation in peaceful demonstrations sitting at lunch counters or lying down in the street.

All of these images are moving, but, looking over the selection presented here, it is the color photographs of the 1966 Chicago Freedom Movement that strike a chord with me. The crowds of people in vivid color, juxtaposed with the black-and-white photograph of crowds on the National Mall in 1963, appear as if they are generations apart. Yet, the Chicago Freedom Movement was Dr. Martin Luther King Jr.'s attempt to bring arguments for social justice in equal housing to the North through nonviolent means, barely a year after the 1965 Selma to Montgomery march for civil rights and social justice.

I am grateful to both Representative John Lewis and Bryan Stevenson, Executive Director of the Equal Justice Initiative, for their thoughtful contributions to this book.

As a young man, John Lewis was one of the hundreds, even thousands, of youths who put themselves in harm's way to demand recognition, respect, and equality. As a United States Representative, he continues to work to this end as he eloquently expresses the relevance of these struggles to today's generation of world citizens in his essay, "Portrait of a Revolution." Bryan Stevenson's essay, "Reflections for a New Generation," reminds us that an honest examination of the past compels us to question our present with the same honesty, as difficult as it may be.

As a part of the Museum's documentation of the Civil Rights Movement, we collaborated with the Library of Congress on the Civil Rights History Project to document those who were activists in the 1950s and 1960s. In October 2010 we began interviewing people who were involved in the movement as foot soldiers, leaders, and supporters. Brief excerpts from some of these interviews are included in this book, providing first-person context to events pictured in these powerful images. In addition, the photographer James Wallace recounts the night he documented a Ku Klux Klan rally in North Carolina; this experience was radically different from his photojournalism of student protests against segregation in Chapel Hill during 1963 and 1964, also pictured in this book.

Many people contributed to the making of this important book and landmark series. At the Museum, special acknowledgement is due to the publications team: Jacquelyn Days Serwer, Chief Curator; Michèle Gates Moresi, Supervisory Curator of Collections, who acted as team leader on this project; Rhea Combs, Curator of Photography and Film, and Head of the Stafford Center for African American Media Arts; Laura Coyle, Head of Cataloging and Digitization, whose work made the reproduction of these photographs possible; and Aaron Bryant, Mellon Curator of Photography. In addition, the work of Elaine

"The power of photographs is not only the ability to depict events, but to bring human scale to those experiences."

Lonnie G. Bunch III

Nichols, Senior Curator for Culture, has been invaluable to the development and compilation of the Civil Rights History Project interviews.

We are also very fortunate to have the pleasure of co-publishing with D Giles Limited, based in London. At Giles, I particularly want to thank Dan Giles, Managing Director; Alfonso Iacurci and Helen McFarland, Designers; Allison McCormick, Editorial Manager; Sarah McLaughlin, Production Director; and Jodi Simpson, Copyeditor. Others who deserve my thanks include Rex Ellis, the Museum's Associate Director for Curatorial Affairs, Lisa Ackerman, Terri Anderson, David Braatz, Emily Houf, Alexander Jamison, Leah L. Jones, Christopher Louvar, Kirah Nelson, Erin Ober, T. Greg Palumbo, Douglas Remley, and Jennie Smithken-Lindsay.

I am so pleased to continue this series with images from the Civil Rights Movement and to share even this small selection with our public. We remain steadfast in our commitment to document African American history, and, like me, I trust you will be inspired by the photography collections at the Smithsonian and beyond.

Lonnie G. Bunch III
Founding Director
National Museum of African American History and Culture, Smithsonian Institution

Portrait of a Revolution

John Lewis
U.S. Representative from Georgia (5th District)

When I was growing up in rural Alabama, we feared the threat of violence, especially when we had to leave the confines of our family farm to travel into town on lonely country roads or visit the nearby town of Troy. We were afraid to speak and afraid to be silent, afraid to look up and afraid to look away. We were afraid to be afraid. The slightest accidental gesture could be seen as provocation and used as an ill-fated reason to arrest us, beat us, take us to jail, run us off our land and out of town. People came up missing, and no one ever heard from them again. People were killed, and no one was ever held accountable. We had no civil rights, and we knew that no one would defend us from these brazen injustices.

In fact, many elected officials and police officers were members of the Ku Klux Klan during that time. Not only did they look the other way, they actively participated in brutality. Thousands of people were killed whose deaths were never prosecuted or pursued. Decades earlier, the Thirteenth and Fifteenth Amendments had freed the slaves and actually made it legal on paper for black citizens to vote. But the laws of segregation and racial discrimination—not only in the Deep South, but in other parts of America as well—nullified those rights.

Most people yearned for a way out of this oppression, known as "Jim Crow" segregation, which had been in place since the end of Reconstruction, almost one hundred years earlier. Its roots reached back several hundred years to when slaves from Africa were trafficked around the world by the millions. By 1964, most people thought legalized segregation had been in place so long it would never change. And its tyranny affected not only blacks, but also whites, who knew it was wrong but were too terrified to speak the truth. That is why so many people of my generation, of all races and nationalities, are deeply indebted to the work of Dr. Martin Luther King Jr. and Rev. Jim Lawson.

Through their ability to adapt the tactics and philosophy of Mohandas Gandhi to our American sensibilities and beliefs, those men laid the groundwork for a nonviolent

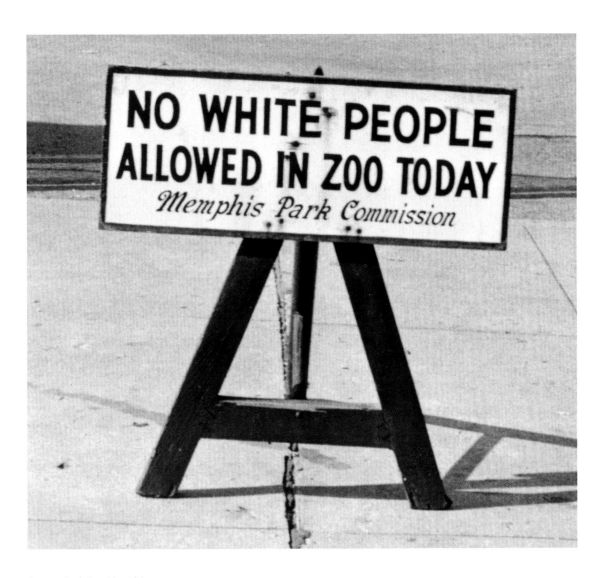

Overton Park Zoo, Memphis,
Tennessee, 1950s (detail)
Ernest C. Withers

revolution, a revolution of values and ideas, that has changed this nation forever. Dr. King taught us how to stand up, speak up, and speak out without employing the stigma of vengeance and crimes of violence. He taught us how to defend our dignity with methods that helped imbue us with the power to be more humane, even in the face of bitter conflict. Dr. King was the inspiration for nearly every single person depicted in this book to take a stand for justice in their own lives. And because they stood up, a massive transformation swept the nation and changed the shape of American democracy.

When I was a child I saw those signs that said WHITE WAITING, COLORED WAITING, WHITE MEN, COLORED MEN, WHITE WOMEN, COLORED WOMEN. Despite amendments to the Constitution, it was illegal for any minority to register and vote; to sit next to a white person on a bus, in a cab, at a lunch counter; to sleep under the same roof of any hotel as a white person; to date someone white or marry him or her. This was how all Americans lived. The Civil Rights Movement of the 1960s, in a short period of about ten years, changed all of these centuries-old traditions, demonstrating a means and methodology called nonviolent direct action that had the ability to transform the most powerful nation on Earth. That is why it is celebrated worldwide as a marvel of history.

I have traveled to many countries— India, Ireland, Germany, England, Egypt, and South Africa among them. The Civil Rights Movement is revered as a crowning achievement in the unending struggle for human liberation. And because of its effectiveness, it laid the groundwork for all the civil rights movements that followed—the women's, immigration, disabled, gay, and other equality movements that we see in America— as well as the liberation movements of the Arab Spring, and those in Eastern Europe and other nations.

That is why we must continue to visit and revisit this history, to remind ourselves that the struggle for equal justice in America is not over. We have much more work to do. We must use the lessons of this transformation in our present-day work for liberation, equality, and justice here and around the globe. We must ensure that no power—government or corporate—infringes on the divine liberties bestowed upon every human being by our Creator.

What are civil rights? They are immutable mandates that apply not only to African Americans, but all Americans. That is why this history is relevant to all of us. As Dr. King would say, "A threat to justice anywhere is a threat to justice everywhere." I hope you will enjoy this commentary and

the photographs from the collections of the National Museum of African American History and Culture. And when you are called to action, I hope you will do your part. I hope you will join in the struggle for simple justice that respects the dignity of every human being to help build a nation and a world community that is finally at peace with itself.

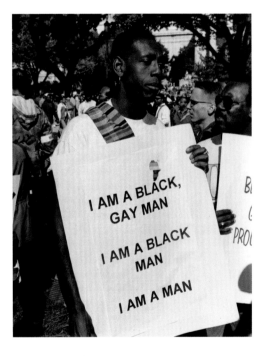

I Am a Man, October 16, 1995
From the series One Million Strong
Roderick Terry

Reflections for a New Generation

Bryan Stevenson
Executive Director of the Equal Justice Initiative

My grandmother was born to parents who were formerly enslaved in Caroline County, Virginia. Her father learned to read on a plantation, where he kept his reading skills secret, sharing them only with other enslaved people his family trusted. When Emancipation came at the end of the Civil War, he read everything he could find to learn what would become of African Americans. He slowly realized that the myths and narratives about black inferiority and the thinking that caused people of African descent to be seen as less than human were not addressed by the Emancipation Proclamation (1863) or the Thirteenth Amendment (1865), making true freedom illusive. By the time my grandmother was born in the 1880s, her father recognized that slavery hadn't ended as much as it had evolved.

The collapse of Reconstruction (1865–77) that surrounded my grandmother's birth marked a dangerous time in America for people of color, whose lives were shaped by terrorism and racial violence. Native Americans were being hunted and violently sequestered into designated spaces while they fought cultural annihilation of their customs and traditions. Asian immigrants were targets of exploitation and discriminatory practices while Mexican and Latin American immigrants were ruthlessly gunned down and attacked in border states throughout the Southwest. Many states enacted "racial integrity laws" that prohibited interracial marriage or sex and "race mixing." Some states legalized the forced sterilization of women of color and the poor to control population growth.

For African Americans, especially in the South, the period from the end of Reconstruction in the late 1870s through World War II was particularly traumatizing and perilous. White Southerners violently eliminated the freedom and opportunities formerly enslaved people were promised and constructed a racially regulated society in which racial subordination and humiliation of black people was legally required. African Americans were terrorized on a daily basis with lynchings and threatened violence. Convict leasing laws authorized criminal justice system officials to arrest tens of

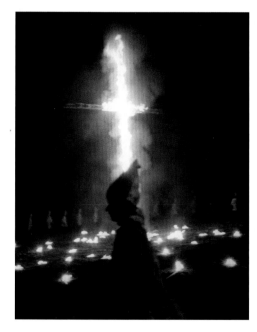

*A White Shadow in the
Night*, 1964; scanned 2010
James H. Wallace

thousands of black people on trumped-up
charges that sent them to prison for years.
Imprisoned black men, women, and children
were then "leased" to private companies and
re-enslaved in labor conditions more brutal
and lethal than those of formal slavery; the
Thirteenth Amendment expressly exempted
people convicted of crimes from the prohibition
against slavery.

At the beginning of the twentieth
century, many Southerners rewrote the
story of the Civil War, romanticized the
Confederacy, and established the politics of
white supremacy. A new historical narrative
of the South emerged that legitimated
racial oppression and domination of African
Americans. "Jim Crow" laws segregated
black and white people and were used to
dehumanize and demean African Americans.
When legal challenges were brought against
these laws, the United States Supreme Court
routinely denied the claims and refused
to offer any remedies or protections that
might provide equal treatment. The violence
against and economic exploitation of black
people was so intense that millions of African

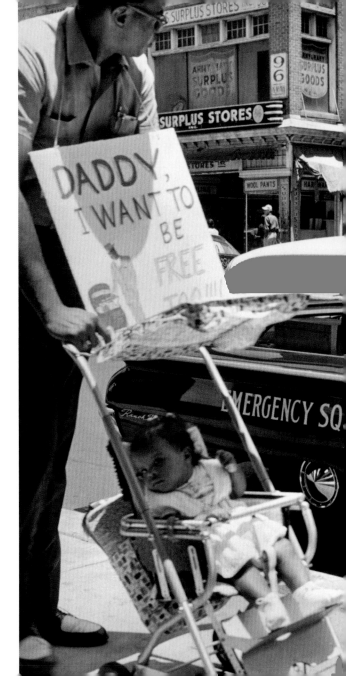

William Edwin Jones Pushes
Daughter Renee Andrewnetta Jones
(8 Months Old) during Protest March
on Main St. in Memphis, Tennessee,
August 1961 (detail)
Ernest C. Withers

Americans fled the South to urban areas in the North and West.

By the end of World War II, even though executions by states had replaced lynchings in the South (with only marginally more reliability and process) and black soldiers had fought valiantly in the U.S. military, the social, economic, and political conditions of millions of African Americans remained bleak. A racial caste system denied black people the right to vote, access to equal education, economic opportunities, and any chance at a life free of terror and humiliation.

Against the backdrop of this history of racial injustice, African Americans who had been enslaved, terrorized, traumatized, humiliated, threatened, and disenfranchised began to organize for a massive campaign of nonviolent resistance to decades of racial inequality. They were determined to change America, and their efforts transformed this nation and inspired people around the world.

Unlike the violent slave rebellions of ancient Rome or the militarized revolts against political oppression seen in many countries, the American Civil Rights Movement was galvanized by unarmed clergy, lawyers, students, activists, and ordinary people with extraordinary vision and courage. From Rosa Parks, the humble seamstress who inspired the Montgomery Bus Boycott in 1955, to Birmingham schoolchildren who filled jails as part of the Children's Crusade in 1963, to white and black college students who brought Freedom Summer to Mississippi in 1964, the Civil Rights Movement challenged the character of America and its commitment to basic human rights with such astonishing clarity that racial hierarchy began to crumble. Civil rights activists and leaders nobly avoided the curse that comes with hating one's opponents and inflicting retributive violence.

Between 1955 and 1965, the struggle for civil rights produced dramatic and unforgettable moments of courage and commitment. Each of us should reflect on the images and events of that era presented in this wonderful new collection because never before in American history have people so marginalized done so much to demonstrate the power of basic human rights armed only with courage, commitment, and love. But it is important to understand that the struggle for

racial justice began long before the images depicted in these pages, and it continues today. It was the hope of equality that led my great-grandfather to learn to read while enslaved in the 1850s. The landmark Voting Rights Act of 1965 gave my grandmother the right to vote, but her hope for full equality did not end there.

She wanted—maybe even needed—an opportunity to give voice to what growing up in terror, haunted by lynchings, humiliated by Jim Crow laws, and excluded from basic opportunities had done to her and her family. She thought there should be space in this country to tell the truth about what our legacy of racial inequality has done to all of us. Like many others, she recognized that without fully acknowledging the truth of our past, we cannot reconcile ourselves to a future with the necessary commitment to racial equality for justice to prevail. Truth and reconciliation was essential in South Africa after the collapse of apartheid. It has been critical for Rwanda's recovery from a horrific genocide. And it is still needed today in America. Generations of white people were taught to believe they are superior because they are white, and those who know this to be untrue have done very little to help them recover from this conceit. Millions of black people who survived segregation and

racial subordination have been battered and injured by their experiences. Without telling the truth about our past, we can't ensure the kind of future that honors the courage of the participants in the civil rights struggle.

Thinking about our nation's history of racial inequality doesn't come easy for many of us. It's tempting to soften the narrative and focus only on the moments of triumph and extraordinary courage while avoiding the pain, the episodes of devastating destruction, and tragic oppression. But we ignore the difficult parts at our peril.

In many ways, the challenge for racial equality continues today because we have failed to commit ourselves to honest reflection on the legacy of racial inequality. Today, one in three black male babies born in the United States is expected to go to jail or prison during his lifetime. Mass incarceration has had such a devastating impact on black and brown communities it has been described by some scholars as "the new Jim Crow." Schools have become increasingly resegregated by race as a result of policies that have undermined integration gains from a generation ago. Many African Americans feel their voting rights are once again being restricted and burdened by voter ID laws and other voting limitations and obstacles that have a disproportionate impact on communities of color. Nearly half of all black children live near or below the federal poverty line, and almost all black and brown people are shadowed by a presumption of guilt that makes them a target in schools, on the street, in stores, in the criminal justice system, and throughout American society. Much remains to be done.

The images in this new collection are compelling and important. They demand our attention. These photographs should also inspire us. So many people gave so much for greater justice, opportunity, and racial equality in this country. We can honor them only if we embrace the vision, courage, and commitment to racial justice that these images reflect and confront the challenges that yet remain. My grandmother once told me, "Justice means sometimes you have to stand when everybody else keeps sitting and speak even if everyone else is quiet." These photographs remind us that my grandmother got it right, and that the hope of civil rights and justice now resides in all who bear witness to these images and choose to stand and speak.

**"Tent City" Family,
Fayette County,
Tennessee**, 1960
Ernest C. Withers

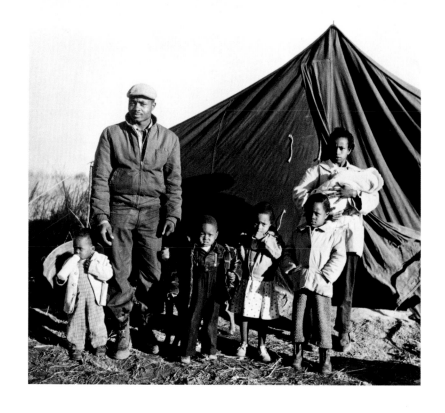

*"In the county called Fayette in the state of Tennessee
Freedom City stands for all the world to see
Tenants driven from their homes just across the way
In tents now they live but here is what they say:*

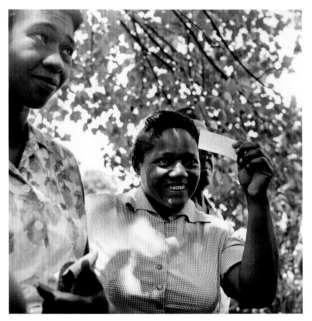

Young Woman Receives Her Voter Registration Card, Fayette County, Tennessee, 1960
Ernest C. Withers

—

In 1960, in western Tennessee, African Americans in Fayette and Haywood Counties were blacklisted, refused goods and services, and threatened because they had registered or planned to register to vote. Afraid of losing the status quo and political power to African Americans who made up a substantial majority, whites retaliated. As a result, many African Americans lost their jobs and homes as white property owners evicted hundreds of sharecroppers and their families from tenant farms across the region. While some black families moved out of the counties, others migrated to settlements erected for evicted farmers known as the "Fayette County Freedom Village" or "Tent City." In time, Tent City came to the attention of the national press, the Kennedy Administration, and the Department of Justice. Eventually the federal government filed a lawsuit under the 1957 Civil Rights Act.

*We were born in Fayette County, here we will stay
It'll take more than eviction to drive us away..."*

Sung by Pete Seeger, lyrics by Agnes Cunningham

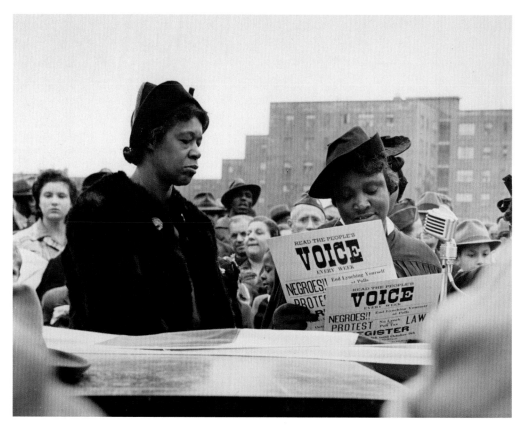

People's Voice, 1940s
Joe Schwartz

Gospel singers from
the Harlem Abyssinian
Baptist Church outside the
Kingsboro Housing Project
in Brooklyn, New York.

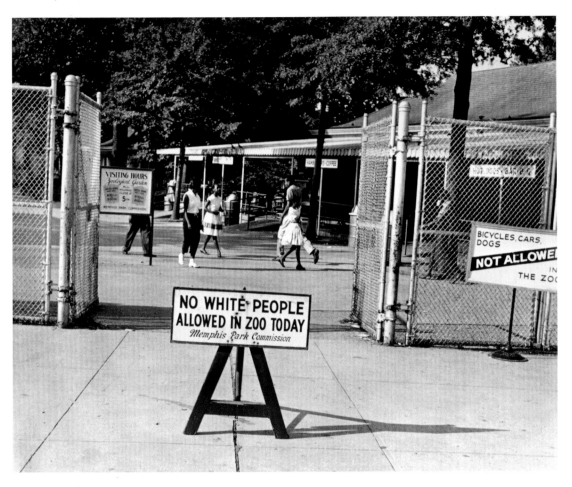

Overton Park Zoo.
Memphis, Tennessee,
1950s
Ernest C. Withers

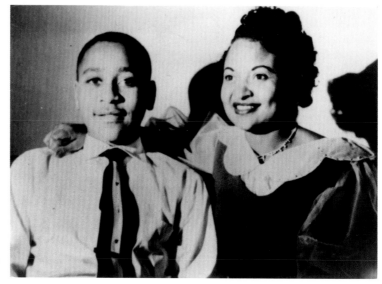

Emmett Till with his mother, Mamie Bradley, ca. 1953–55; printed later
Unidentified photographer
—
Emmett Till's murder sparked reactions from both the national media and the American public. The brutality of his death demonstrated the extent to which murder and violence against African Americans were commonly accepted and often overlooked in the South. Till's murder marked a tipping point. People across the country knew something had to change if America was to live up to its ideals of freedom and democracy. When Emmett's mother insisted that her son's mutilated face and body be presented at his funeral in an open casket, Emmett became a national symbol of everyone's child.

"Emmett Till and I were about the same age. A week after he was murdered... I stood on the corner with a gang of boys, looking at pictures of him in the black newspapers and magazines. In one, he was laughing and happy. In the other, his head was swollen and bashed in, his eyes bulging out of their sockets and his mouth twisted and broken.... I couldn't get Emmett out of my mind..."

Muhammad Ali, 1975

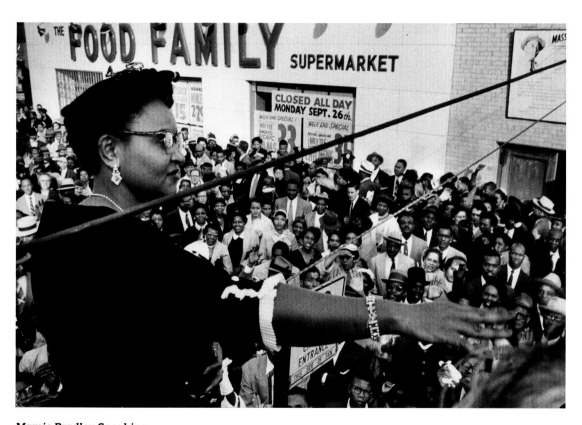

*Mamie Bradley Speaking
to Anti–Lynching Rally
after Acquittal of Men
Accused of Killing Her
Son, Emmett Till, Harlem,
New York*, 1955
Grey Villet

Members of the San Francisco chapter of the National Council of Negro Women (NCNW) launch the Citizen Education Project (CEP), a drive designed to increase voter registration in the Bay Area. From left to right, Lurline White, Sallie Edwards, Lulu Carter, Illa Buckner, Beulah Staton, Eddye Keaton Williams, Margaret Buford, Cathryn Williams, Esther Wise, and Dola Miller wait for a motorcade to pass. This image is part of a scrapbook of photographs and news clippings compiled by Francis Albrier (1898–1987) during her term as president of the San Francisco NCNW in 1956–57. Albrier, the granddaughter of a former slave, spent nearly six decades as a civil rights activist in and around Berkeley, California.

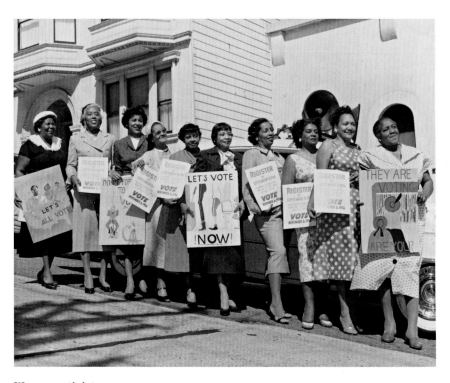

Women activists with signs for voter registration,
September 8, 1956
Cox Studio

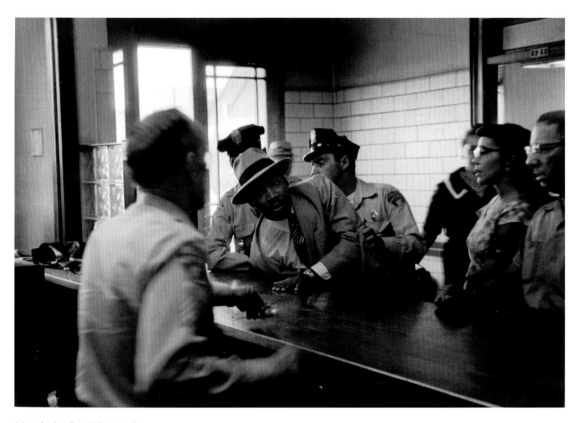

**Martin Luther King Jr. is
Arrested for Loitering Outside
of a Courtroom Where His
Friend Ralph Abernathy
Is Appearing for a Trial,
Montgomery, Alabama**,
1958; printed 2007
Charles Moore

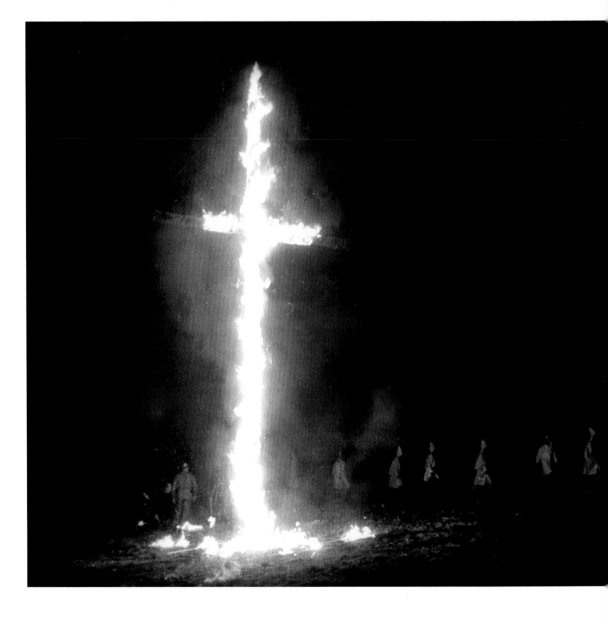

Untitled, 1964;
scanned 2010
**Ku Klux Klan
rally and cross
burning, held in the
summer of 1964 at
the intersection
of North Carolina
State Road 86 and
Interstate 85
between Chapel
Hill and Hillsboro,
North Carolina**
James H. Wallace

For a journalism student at the University of North Carolina at Chapel Hill, it was certainly very strange to get a news release from the Ku Klux Klan. The local civil rights Freedom Movement, with a goal of desegregating all restaurants in Chapel Hill, had launched ongoing marches, picketing, and sit-ins, leading to numerous arrests. For those of us working on the school's weekly summer newspaper, *The Tar Heel*, it was our biggest continuing story.

Now, the KKK was announcing a public "recruiting rally" just outside town. Because we had been covering the events in Chapel Hill, a friend and reporter, Mickey Blackwell, and I decided to cover the rally. We were told that the North Carolina State Police would be there directing traffic. When we arrived the police were nowhere to be seen. We parked, and as we walked up a hill towards the as-yet-unlit cross, we were stopped by Klansmen and asked to identify ourselves. I had my camera clearly showing around my neck. After a brief discussion they let us in. Strangely they did not bother or hinder us further. Later it occurred to me that because of my last name, Wallace, they might have thought I was related to George Wallace, the then-governor of Alabama.

I shot a roll of black-and-white film using only the light from the cross-burning ceremony. When the rally ended, Mickey and I left quickly. We were both quite shaken and genuinely scared, agreeing it was probably not the smartest thing we had ever done.
— James H. Wallace, 2014

29

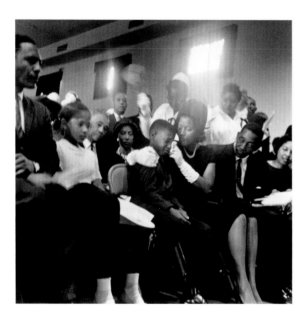

***Mrs. Medgar Evers and Family—
She Comforts Her Eldest Son at
Medgar Evers's Funeral, Jackson,
Mississippi***, June 15, 1963
Ernest C. Withers

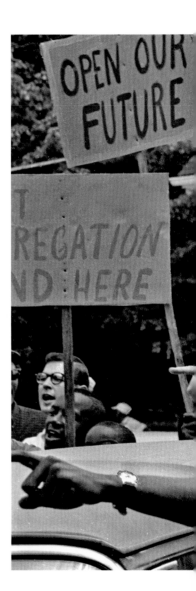

***Demonstrators Hold a Church
Rally before Marching to
Downtown Chapel Hill***, 1960s;
scanned 2010
James H. Wallace

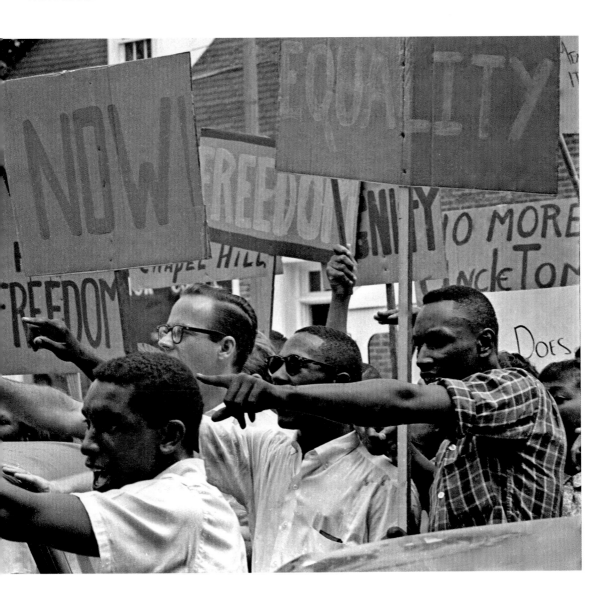

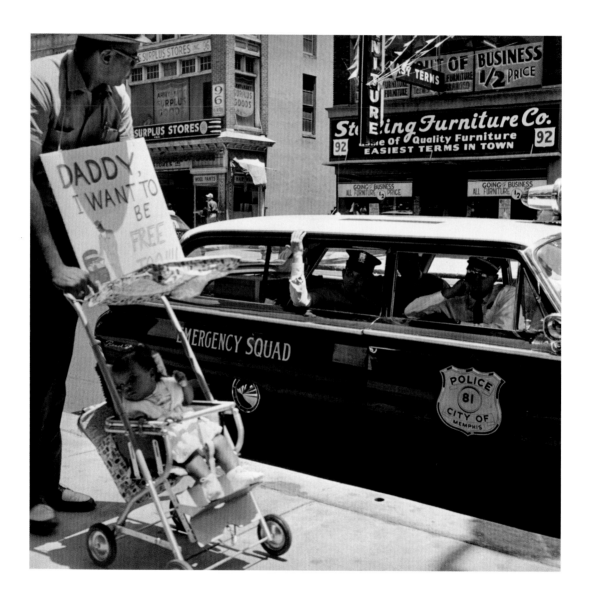

***First Day of
Memphis
Integration,
Tennessee***, 1961
Ernest C. Withers

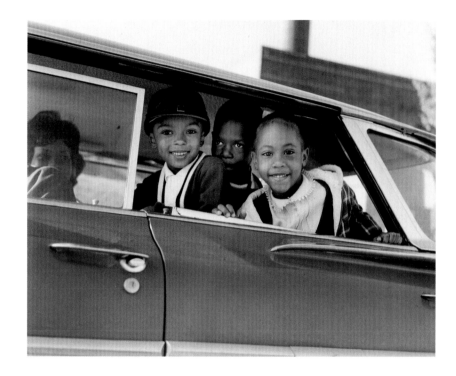

***William Edwin Jones
Pushes Daughter
Renee Andrewnetta
Jones (8 Months
Old) during Protest
March on Main St. in
Memphis, Tennessee***,
August 1961
Ernest C. Withers

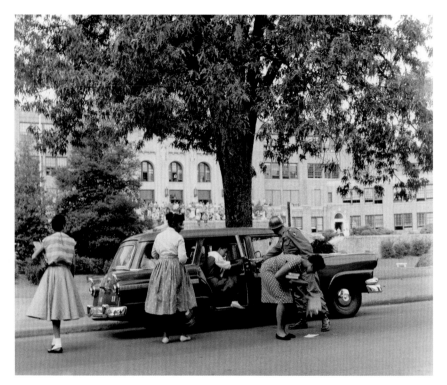

**Desegregation
of Central High
School, Little Rock,
Arkansas**, 1957
Ernest C. Withers
—
The Little Rock Nine
was a group of African
American students who,
in 1957, were the first
black students ever to
attend classes at Little
Rock Central High School
in Little Rock, Arkansas.
In 1999, the Little Rock
Nine was awarded the
Congressional Gold
Medal by President
William J. Clinton.

*"We realized in 1957 that this was not an easy
journey. It was one in which we thought we were
simply exercising our right to the best education
that was available in Little Rock, Arkansas."*

Ernest Green, one of the Little Rock Nine

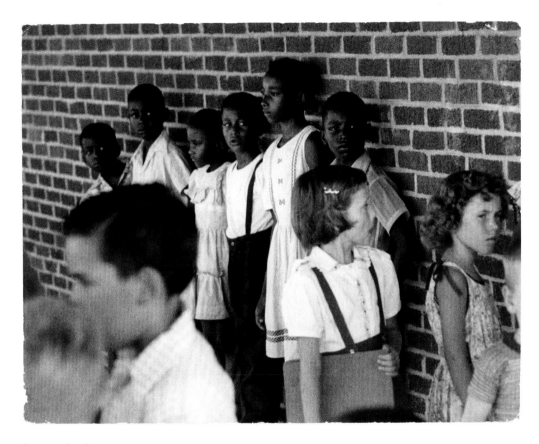

Integration in Oklahoma, First Day of School for Black Kids,
1955–58
Gordon Tenney

*"Singin' about a revolution
Because we're talking about a change
It's more than just evolution...
The only way that we can stand in fact
Is when you get your foot off our back."*

Lyrics by Nina Simone and Weldon Irvine

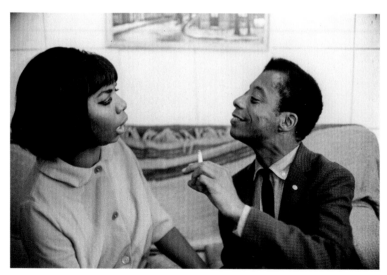

**Nina Simone with
James Baldwin**, 1965
Bernard Gotfryd

—

Nina Simone and James
Baldwin were both
outspoken twentieth-
century artists committed
to addressing sociopolitical
issues in their songs
and writings. Baldwin
is often credited with
helping expose Simone to
literature that would help
shape her work, and she
remained a good friend
until his death in 1987.

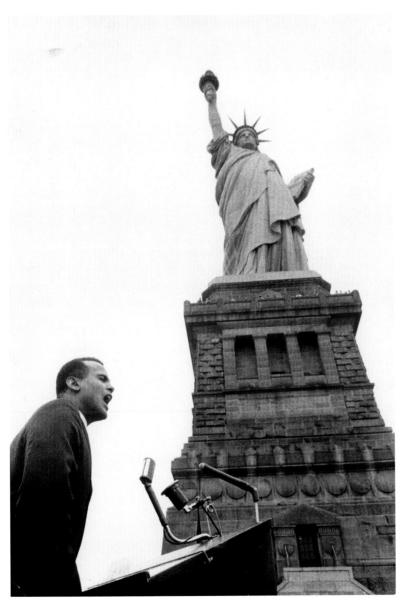

"You can cage the singer but not the song."

Harry Belafonte, 1988

Singer Harry Belafonte, Speaking at Civil Rights Rally at Statue of Liberty, 1960
Albert Fenn

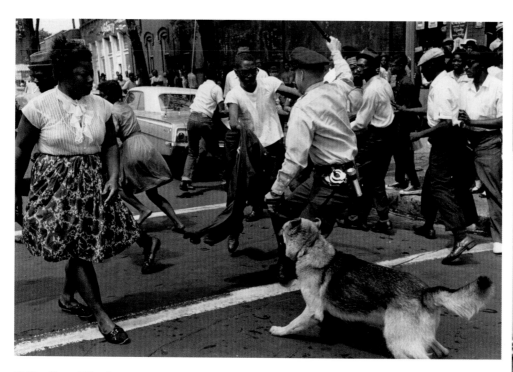

***Police Dogs Attack
Demonstrators,
Birmingham Protests***,
1963; printed later
Charles Moore

***Alabama Fire
Department Aims
High-Pressure Water
Hoses at Civil Rights
Demonstrators***, May
1963; printed 2007
Charles Moore

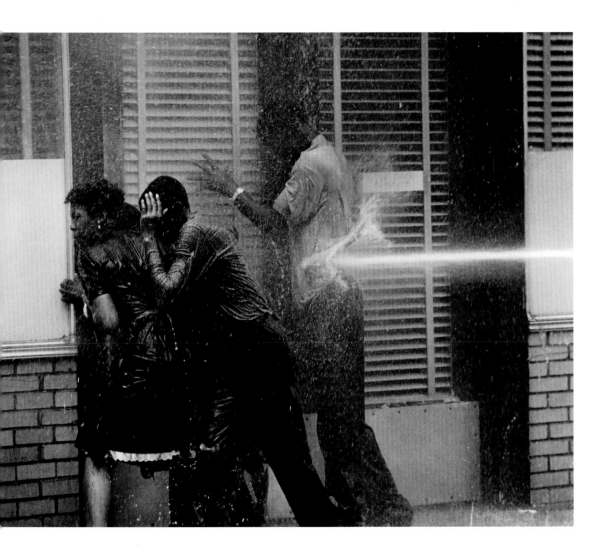

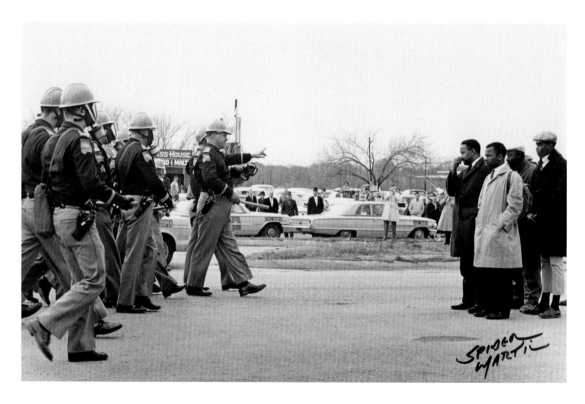

"If not us, then who?
If not now, then when?"

Rep. John Lewis, 1961

Two Minute Warning,
1965; printed 1995
Spider Martin

Courage, 1965;
printed 1995
Spider Martin
—
In the spring of 1965,
thousands of people
gathered for what
became the largest civil
rights demonstration in
the state of Alabama.
Over a period of eighteen
days, people marched
fifty-four miles (eighty-
seven kilometers) along
Highway 80 from Selma
to Montgomery. The
march was interrupted
with violent force by local
law enforcement, and
by periods of rest and
recuperation. By the final
day of the trek—March
25, 1965—almost thirty
thousand people were
standing at the entry
into the state capital.
Photographs offer a
glimpse of the power and
range of the people who
came together, despite
the threat of violence
and harsh conditions,
to march, organize, and
advocate for social justice
and voting rights.

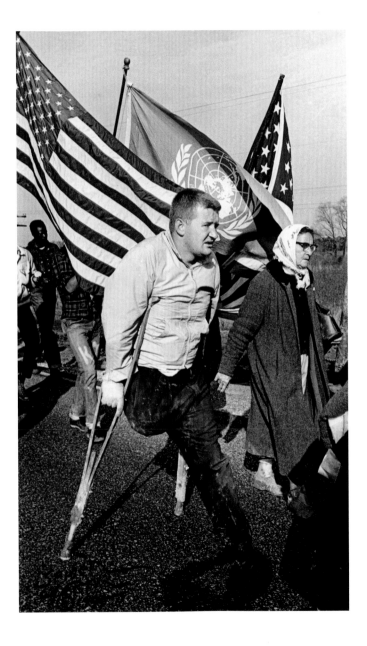

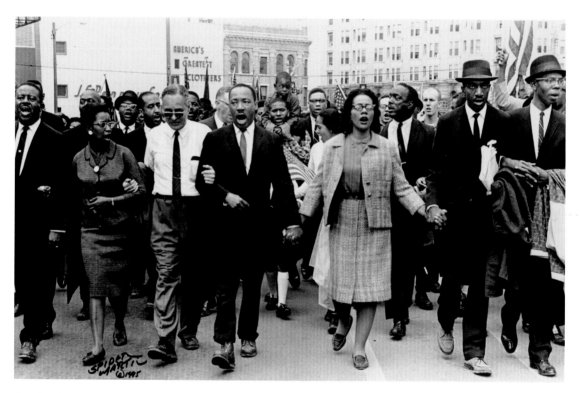

***Coming into
Montgomery***, 1965;
printed 1995
Spider Martin

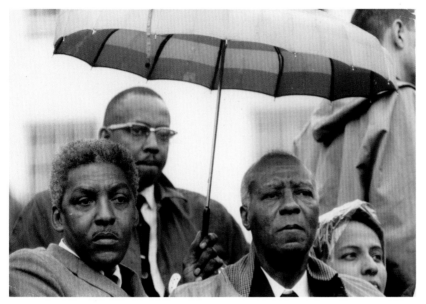

Selma March, 1965
**Civil Rights Leaders
Bayard Rustin and
A. Philip Randolph**
Steve Schapiro

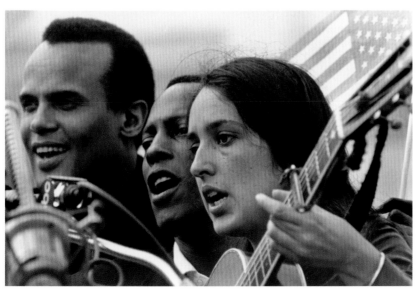

**Joan Baez, Selma to
Montgomery March,
1965**, printed ca. 1990
Charles Moore

—

Harry Belafonte (far
left) and Leon Bibb
(center) join Joan Baez
at the microphone

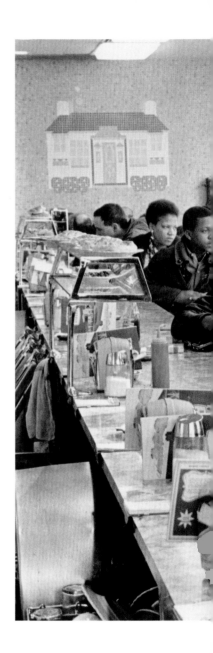

**Atlanta, Georgia.
A Toddle House
during a Sit-In**, 1963;
printed 1994
Danny Lyon

"But the older people,
the more mature people,
wanted not to move
so fast. And the young
people wanted to move
now. They didn't want to
wait twenty years to come
from the back of the bus.
They didn't want to wait
twenty years to sit at a
lunch counter."

Anne Pearl Avery, 2011

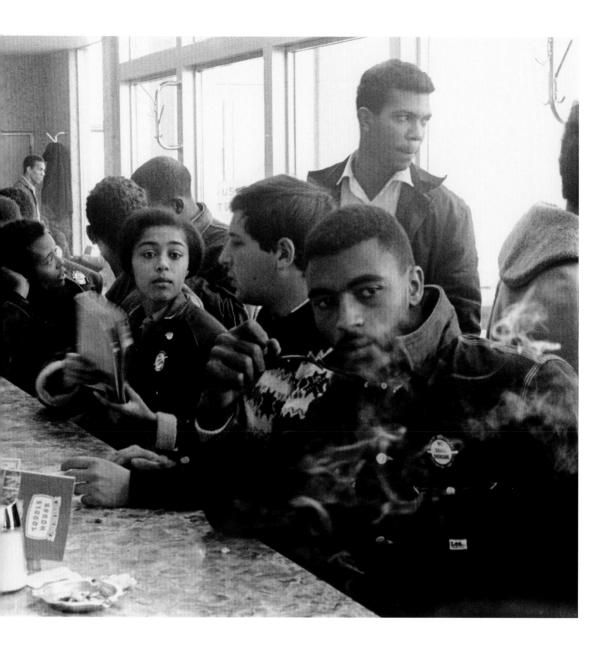

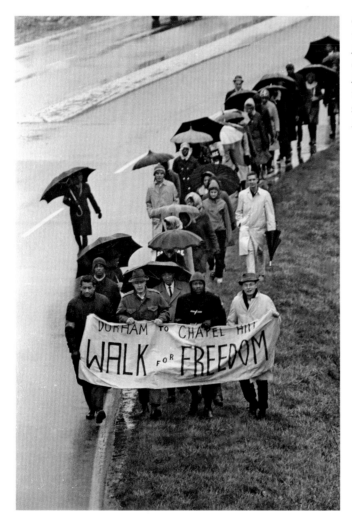

On January 12, 1964, the Chapel Hill Freedom Committee Organized a 13-Mile March from Durham to Chapel Hill, 1964; scanned 2010
James H. Wallace

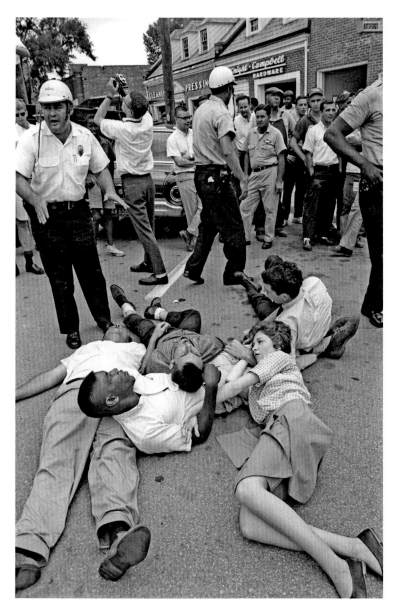

The First Sit-In by the Chapel Hill Freedom Movement, at the Chapel Hill Merchants Association, July 29, 1963; scanned 2010
James H. Wallace

Crowds Surrounding the Reflecting Pool, Reaching Back to the Washington Monument at the March on Washington for Jobs and Racial Equality, 1963
Bruce Davidson
—

The city of Washington, D.C., had never seen a demonstration of this magnitude. Around the world, millions watched on television as 250,000 people came together to demand social justice. The events of that day helped mark the centennial of the Emancipation Proclamation and reminded Americans of the nation's long pursuit to fulfill its founding principles of liberty and equality for all.

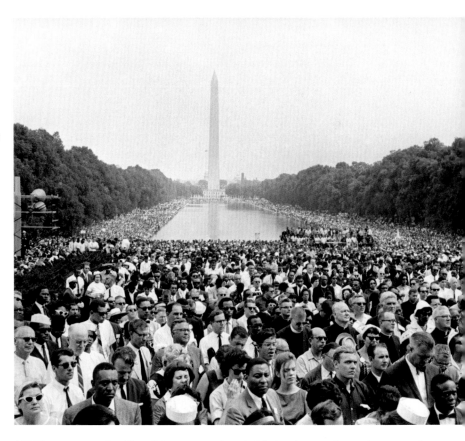

"We were full of hope that this is going to make a difference. Seeing people from all walks of life, children and old people and young people and entertainers, and hearing the speeches, and being there...pulling it off was just so inspiring

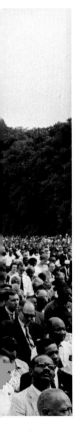

The March on Washington. August 28, 1963; printed 1994
Danny Lyon

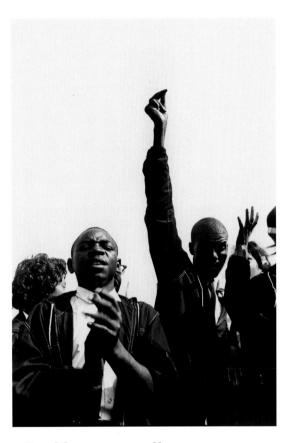

because there was no violence…. And here are all these people…black, white, Asian, people from all different ethnic backgrounds, different countries, out there….that was very exciting to see."

Dr. Doris Derby, 2011

**Southwest Georgia. Student
Nonviolent Coordinating
Committee Field Secretary
Charles Sherrod and Randy
Battle**, 1963; printed 1994
Danny Lyon

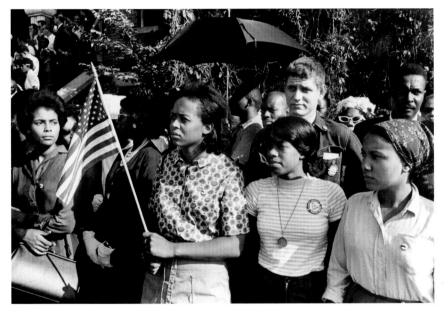

Birmingham, Alabama. Student Nonviolent Coordinating Committee Workers Outside the Funeral, 1963
Danny Lyon

—

On Sunday morning, September 15, 1963, a bomb exploded at the 16th Street Baptist Church in Birmingham, Alabama— a church that served as a meeting place for civil rights leaders. Four young girls were killed and many others were injured. The bombings marked a turning point in the Civil Rights Movement and galvanized national support for passage of the Civil Rights Act of 1964. Pictured here, from left to right, are Emma Bell, Dorrie Ann Ladner, Donna Richards, Samuel C. Shirah Jr., and Doris Derby.

"[W]e didn't have time to savor things, the March [on Washington] or anything else. But I remember the contradiction...all these people there, and then we are...at a funeral of the most vulnerable people of all..."

Dr. Joyce Ladner, 2011

Washington, D.C. ·
USA, 1965
Leonard Freed
—
The March on Washington
captured the nation's
attention and was
recognized early on
as a watershed event.
The pennant in this
photograph marks the
second anniversary of
the march.

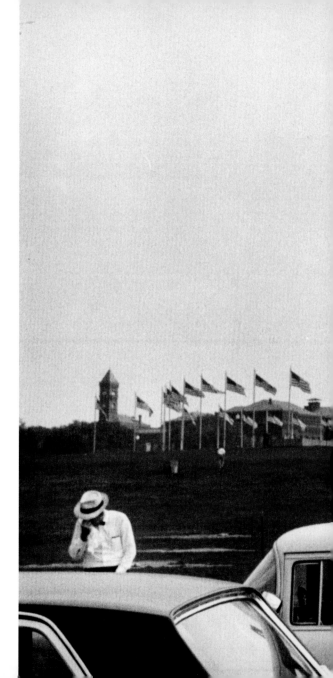

**Freedom Democratic
Headquarters,
Holmes Co.,
Mississippi**, ca. 1965
Maria Varela

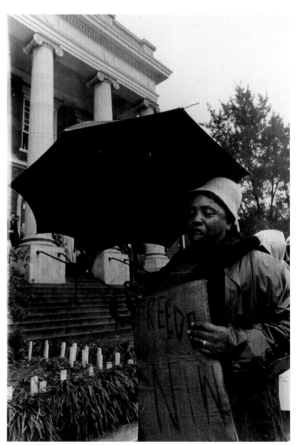

**Freedom Day
in Hattiesburg,
Mississippi**, 1964
Matt Herron

Fannie Lou Hamer picketing
outside the Forrest County
Courthouse.

"Sometimes it seems like to tell the truth today is to run the risk of being killed. But if I fall, I'll fall five feet four inches forward in the fight for freedom."

Fannie Lou Hamer, 1968

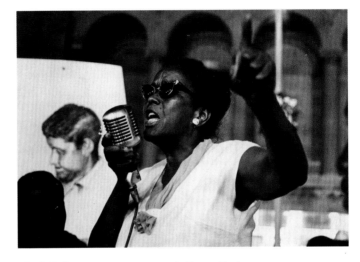

Black Delegates Challenge Mississippi Democrats, 1964
George Ballis
—
Ella Baker addresses the Mississippi delegation at the Democratic National Convention in Atlantic City, New Jersey. Baker, with Fannie Lou Hamer and Robert Parris Moses, founded the Mississippi Freedom Democratic Party (MFDP) when African Americans were prevented from voting in the Mississippi primary election. At the convention, the MFDP's delegation challenged the legitimacy of the Mississippi delegation and demanded to be seated instead. Although the MFDP was unsuccessful in displacing the state delegation, it was able to publicize nationally the mass disenfranchisement of Mississippi's black citizens to the vast audience following the convention.

Untitled (Malcolm X at Michaux's Bookstore—Looking Down), 1962; printed December 2, 2010
Jan Yoors

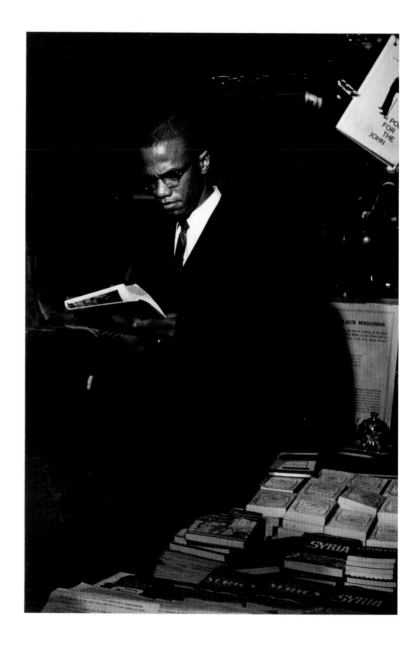

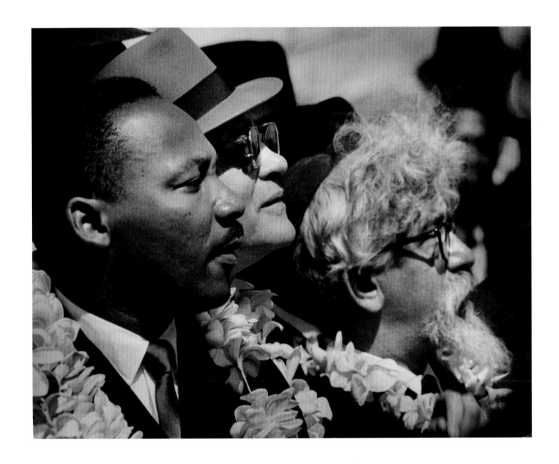

***Martin Luther King Jr.
with Flower Lei
and Leading Rabbis
Maurice Eisendrath and
Abraham Heschel***, 1965
James Karales

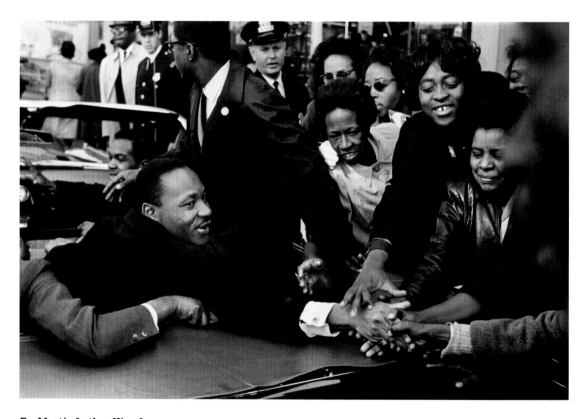

Dr. Martin Luther King Jr. •
Baltimore, Maryland*,*
October 31, 1964; printed 1998
Leonard Freed

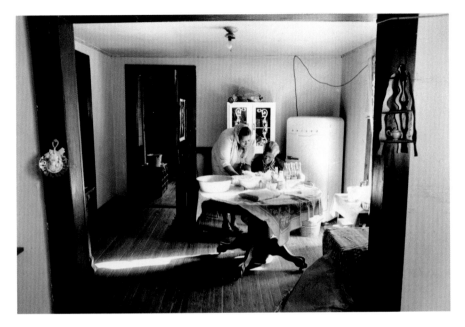

**Voter Registration at a
Kitchen Table, Mississippi**,
1963–64; printed 2008
Charles Moore

"There was something in life that required us to
be as good as we could be and to give back to the
communities from which we came...that led us to be
cognizant of what was happening in the community,
helping people to get registered to vote..."

Dr. Esther M. Terry, 2011

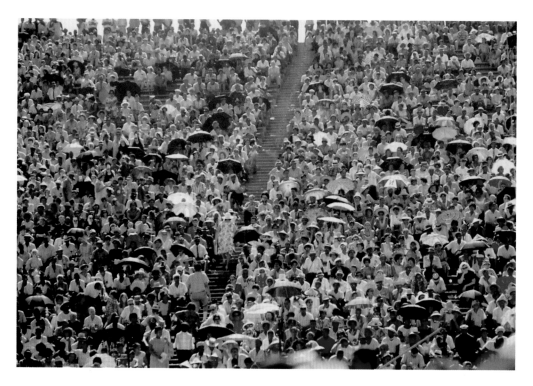

Chicago Freedom Movement rally crowd at Soldier Field, July 10, 1966; printed 2012
Bernard Kleina

Bernard Kleina's photographs document the Chicago Freedom Movement. Also known as the Chicago Open Housing Movement, it was the largest civil rights campaign outside of the South. Events included a freedom rally of over 35,000 people in Soldier Field on July 10, 1966. A few weeks later, Dr. Martin Luther King Jr. led a march through a white neighborhood on Chicago's southwest side, which turned violent. King was hit with a rock and several protestors' cars were torched.

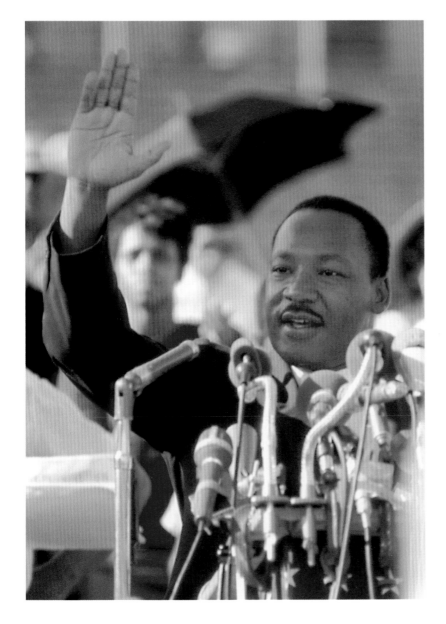

Dr. Martin Luther King Jr. at Chicago Freedom Movement rally, July 10, 1966; printed 2012
Bernard Kleina

A boy walking ahead of soldiers during the Newark Riots,
July 1967
Don Hogan Charles

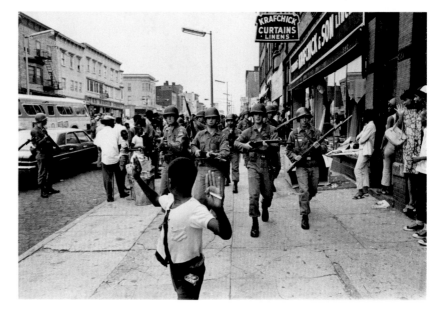

Eviction from Greenville Air Force Base, February 1, 1966
Maria Varela
—

In a telegram to President Lyndon B. Johnson, displaced agricultural workers occupying Greenville Air Force Base declared, "We are here because we are hungry. We are here because we have no jobs.... We demand our right to jobs, so that we can do something with our lives and build us a future."

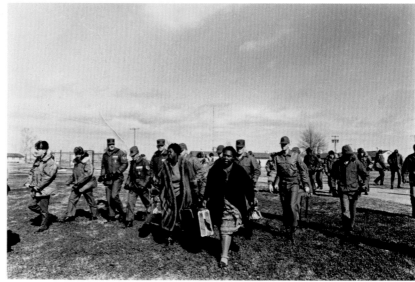

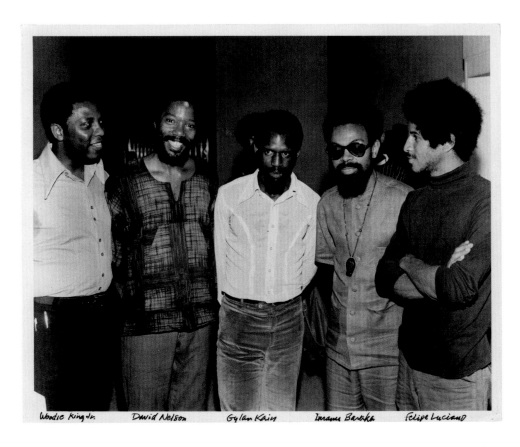

Woodie King Jr. David Nelson Gylan Kain Imamu Baraka Felipe Luciano

The Last Poets with Woodie King Jr. and Amiri Baraka, 1969
Monroe S. Frederick II
—
Emerging during a period of Black Arts and Black Nationalism in the late 1960s, the Last Poets have been recognized as one of the earliest influences on hip-hop music. Members of the Last Poets are pictured with poet and playwright Amiri Baraka, a recognized founder of the Black Arts Movement.

Felipe Luciano, the Last Poets member pictured on the far right, was also co-founder of the New York Chapter of the Young Lords Party, a Puerto Rican rights organization that emerged during the late 1960s.

Lowndes County, Alabama (Vote Nov. 8th Sign), 1966; printed 1994
Bob Fletcher

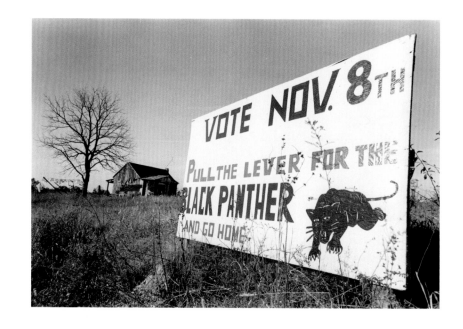

"The Black Panther Party was a seed of a growing movement toward pride in being black... You know, this was, to a sense, authentic African American culture to me....they were cool.... But also they were very dedicated....the idea was to have these various programs that would help develop the community, not just be an antipoverty program, but a program that would help economically develop the black community."

Evans Hopkins, 2011

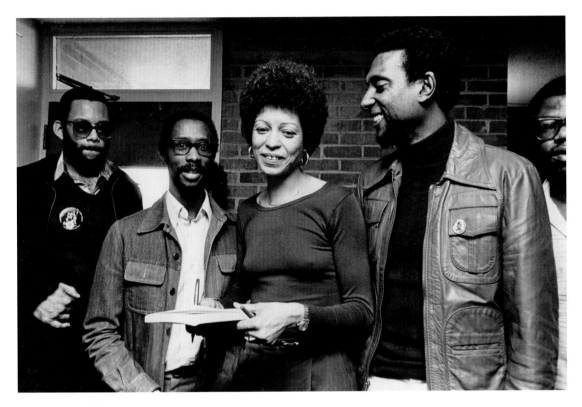

Untitled, ca. 1976
Milton Williams
—
Activist Angela Davis with
civil rights leader Stokely
Carmichael pictured right.

***Stokely Carmichael
at Student Nonviolent
Coordinating Committee
Office, Atlanta, Georgia,***
1967
Gordon Parks

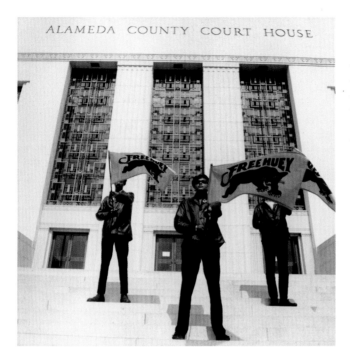

Black Panther Demonstration, Alameda Co. Court House, Oakland, California, during Huey Newton's Trial, #71, July 30, 1968; printed 2011
From the series **Black Panthers 1968**
Pirkle Jones

"Too many so-called leaders of the movement have been made into celebrities and their revolutionary fervor destroyed.... The task is to transform society; only the people can do that—not heroes, not celebrities, not stars. A star's place is in Hollywood; the revolutionary's place is in the community with the people."

Huey Newton, 1973

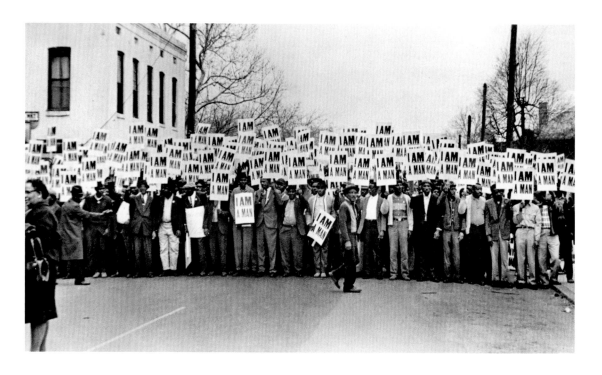

"Something is happening in Memphis; something is happening in our world.... The masses of people are rising up. And wherever they are assembled today, whether they are in Johannesburg, South Africa; Nairobi, Kenya; Accra, Ghana; New York City; Atlanta, Georgia; Jackson, Mississippi; or Memphis, Tennessee—the cry is always the same: 'We want to be free.'"

Dr. Martin Luther King Jr., 1968

Sanitation Workers
Assemble in front of
Clayborn Temple for
a Solidarity March.
Memphis, Tennessee,
March 29, 1968
Ernest C. Withers

—

In March 1968 in Memphis,
Tennessee, sanitation
workers went on strike for
safer working conditions
and decent wages. On April
3, Dr. Martin Luther King
Jr. gave his "I've Been to
the Mountaintop" speech
to the striking workers.
He emphasized the
connection between local
civil rights struggles and
what he called "the human
rights revolution" – a global
movement to unify the
poor and disenfranchised.
Dr. King was assassinated
the next day.

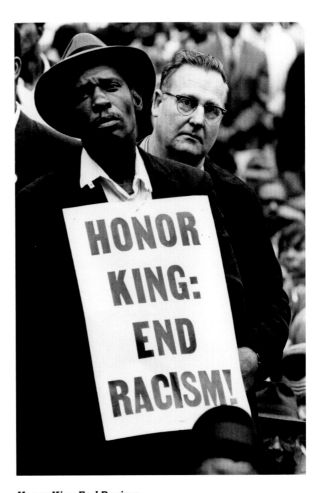

Honor King End Racism,
1968; printed 2012
From the series **Martin**
Luther King Jr. Funeral
Burk Uzzle

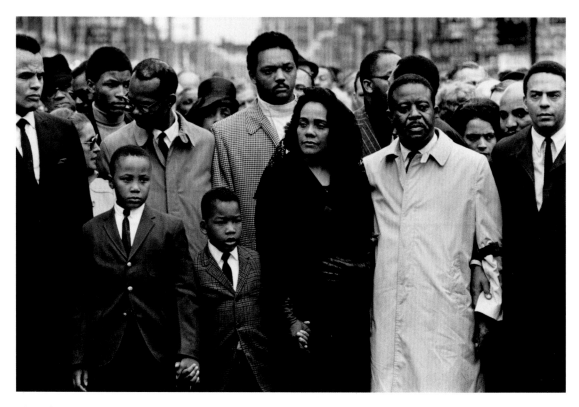

King Family and Friends,
1968; printed 2012
From the series **Martin
Luther King Jr. Funeral**
Burk Uzzle

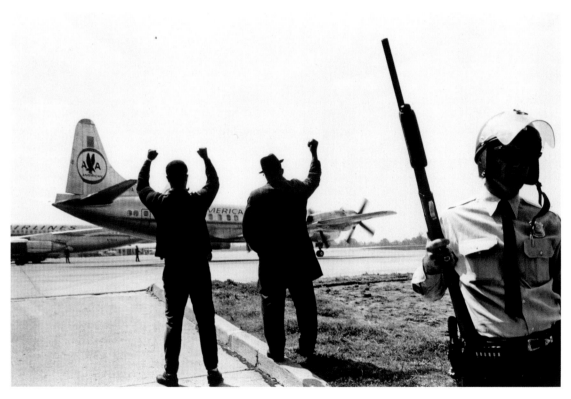

MLK to Atlanta,
1968; printed 2012
From the series **Martin
Luther King Jr. Funeral**
Burk Uzzle

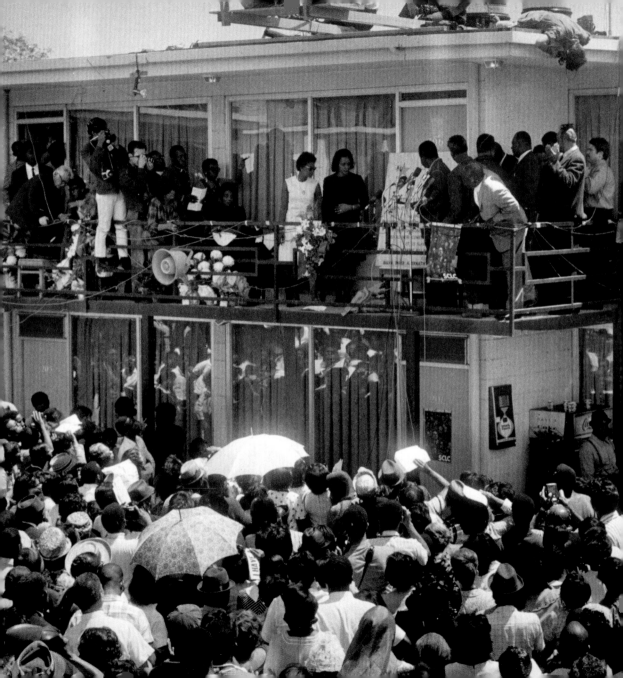

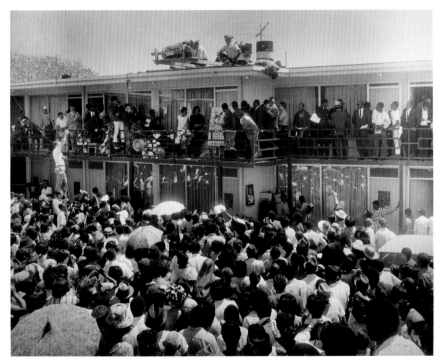

Crowd Outside Lorraine Motel after the Assassination of Dr. Martin Luther King Jr., May 2, 1968
Ernest C. Withers
—
Almost a month after Dr. Martin Luther King Jr.'s death, Coretta Scott King, Rev. Ralph Abernathy, and members of the Southern Christian Leadership Conference (SCLC) returned to the balcony of the Lorraine Motel to unveil a memorial plaque at the sight of the assassination. The event also marked the beginning of the Memphis leg of the Poor People's Campaign, Dr. King's final crusade.

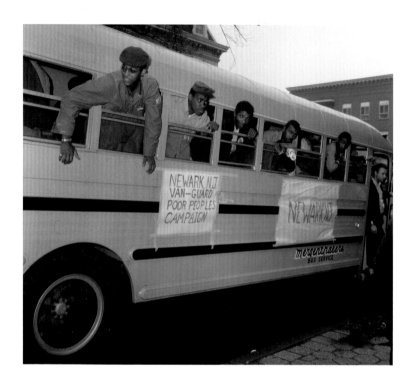

Untitled, 1968
Robert Houston
—
Weeks after Dr.
Martin Luther King
Jr.'s assassination,
demonstrators from
across the country
traveled to Washington,
D.C., to realize his final
plan for a Poor People's
Campaign. Carrying
Dr. King's message of
economic justice, these
protesters occupied the
nation's capital and built
a "City of Hope" along the
National Mall as an act of
civil disobedience. Known
as Resurrection City (May
21–June 23, 1968) the
encampment of yellow
tents served as a platform
from which to demand an
"Economic Bill of Rights."

Untitled, 1968
Robert Houston

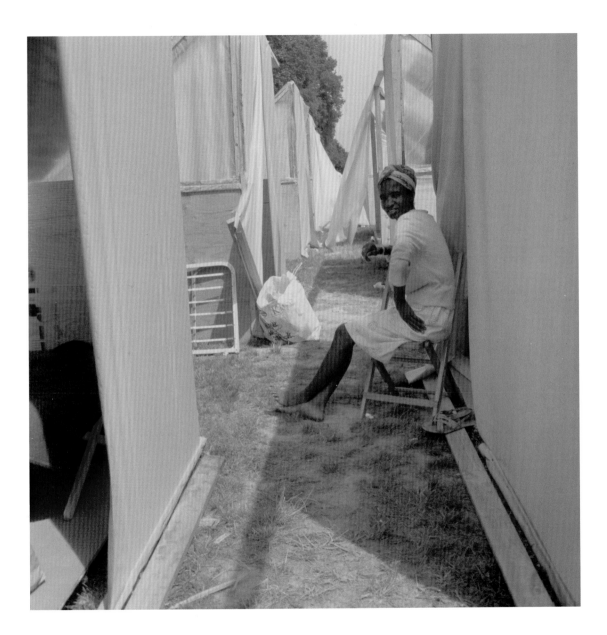

***Rev. Ralph Abernathy
Embracing Rosa
Parks, Benjamin
Hooks on Left,
Southern Christian
Leadership Conference
Convention, Memphis,
Tennessee***, July 1968
Ernest C. Withers

Index

All of the photographic materials are in the collection of the National Museum of African American History and Culture.

Bernard Kleina
Dr. Martin Luther King Jr. at Chicago Freedom Movement rally, July 10, 1966; printed 2012
digital print
H × W (Image and Sheet):
11 × 8½ in. (27.9 × 21.6 cm)
Gift of Bernard J. Kleina and Susan Keleher Kleina
2013.140.1
© Bernard J. Kleina
Page 61

Danny Lyon
Atlanta, Georgia. A Toddle House during a Sit-In, 1963; printed 1994
gelatin silver print
H × W (Image and Sheet):
10¹⁵⁄₁₆ × 13¹⁵⁄₁₆ in. (27.8 × 35.4 cm)
2012.107.16
© Danny Lyon/Magnum Photos
Page 44

Danny Lyon
Birmingham, Alabama. Student Nonviolent Coordinating Committee Workers Outside the Funeral, 1963
gelatin silver print
H × W (Image and Sheet):
10¹⁵⁄₁₆ × 13⅞ in. (27.8 × 35.2 cm)
2012.107.18
© Danny Lyon/Magnum Photos
Page 51

Danny Lyon
The March on Washington. August 28, 1963, printed 1994
gelatin silver print
H × W (Image and Sheet):
13¹⁵⁄₁₆ × 10⅞ in. (35.4 × 27.6 cm)
2012.107.23
© Danny Lyon/Magnum Photos
Page 49

Danny Lyon
Southwest Georgia. Student Nonviolent Coordinating Committee Field Secretary Charles Sherrod and Randy Battle, 1963; printed 1994
gelatin silver print
H × W (Image and Sheet):
10⅞ × 13¹⁵⁄₁₆ in. (27.6 × 35.4 cm)
2012.107.22
© Danny Lyon/Magnum Photos
Page 50

Spider Martin
Coming into Montgomery, 1965; printed 1995
gelatin silver print
H × W (Image and Sheet):
11 × 14 in. (27.9 × 35.6 cm)
2011.14.1
© 1965 Spider Martin
Page 42

Spider Martin
Courage, 1965; printed 1995
gelatin silver print
H × W (Image and Sheet):
14 × 11 in. (35.6 × 27.9 cm)
2011.14.10
© 1965 Spider Martin
Page 41

Spider Martin
Two Minute Warning, 1965; printed 1995
gelatin silver print
H × W (Image and Sheet):
9 × 14 in. (22.9 × 35.6 cm)
2011.14.12
© 1965 Spider Martin
Page 40

Charles Moore
Alabama Fire Department Aims High-Pressure Water Hoses at Civil Rights Demonstrators, May 1963; printed 2007
gelatin silver print
H × W (Image and Sheet):
16 × 20 in. (40.6 × 50.8 cm)
2011.49.1
© Charles Moore
Page 38

Charles Moore
Joan Baez, Selma to Montgomery March, 1965, printed ca. 1990
gelatin silver print
H × W (Image and Sheet):
8 × 10 in. (20.3 × 25.4 cm)
Gift of the Family of Charles Moore
2011.67.2
© Charles Moore
Page 43

Charles Moore
Martin Luther King Jr. Is Arrested for Loitering Outside of a Courtroom Where His Friend Ralph Abernathy Is Appearing for a Trial, Montgomery, Alabama, 1958; printed 2007
gelatin silver print
H × W (Image and Sheet):
11 × 14 in. (27.9 × 35.6 cm)
2011.49.6
© Charles Moore
Pages 19, 27

Charles Moore
Police Dogs Attack Demonstrators, Birmingham Protests, 1963; printed later
gelatin silver print
H × W (Image and Sheet):
16 × 20 in. (40.6 × 50.8 cm)
2011.49.7
© Charles Moore
Page 38

Charles Moore
Voter Registration at a Kitchen Table, Mississippi, 1963–64; printed 2008
gelatin silver print
H × W (Image and Sheet):
11 × 14 in. (27.9 × 35.6 cm)
2011.49.10
© Charles Moore
Page 59

Gordon Parks
Stokely Carmichael at Student Nonviolent Coordinating Committee Office, Atlanta, Georgia, 1967
gelatin silver print
H × W (Image and Sheet):
13¹⁵⁄₁₆ × 11 in. (35.4 × 27.9 cm)
2012.107.28
© Gordon Parks Foundation
Page 66

Steve Schapiro
Selma March, 1965
gelatin silver print
H × W (Image and Sheet):
6¹¹⁄₁₆ × 9¾ in. (17 × 24.8 cm)
2012.107.35
© Steve Schapiro
Page 43

Joe Schwartz
People's Voice, 1940s
gelatin silver print
H × W (Image and Sheet):
11 × 14 in. (27.9 × 35.6 cm)
Gift of Joe Schwartz and Family
2010.74.93
© Joe Schwartz
Page 22

Gordon Tenney
Integration in Oklahoma, First Day of School for Black Kids, 1955–58
gelatin silver print
H × W (Sheet and Image):
8½ × 11 in. (21.6 × 27.9 cm)
Gift of Howard Greenberg Gallery
2012.169.8
Page 35

Roderick Terry
I Am a Man, October 16, 1995
From the series
One Million Strong
gelatin silver print
H × W (Image and Sheet):
14 × 11 in. (35.6 × 27.9 cm)
Gift of Roderick Terry
2013.99.44
© Roderick Terry
Page 13

Ernest C. Withers
*Mrs. Medgar Evers and Family—
She Comforts Her Eldest Son at
Medgar Evers's Funeral, Jackson,
Mississippi*, June 15, 1963
gelatin silver print
H × W (Image and Sheet):
20 × 16 in. (50.8 × 40.6 cm)
2009.16.7
© Ernest C. Withers Trust
Page 30

Ernest C. Withers
*Overton Park Zoo. Memphis,
Tennessee*, 1950s
gelatin silver print
H × W (Image and Sheet):
16 × 20 in. (40.6 × 50.8 cm)
2009.16.2
© Ernest C. Withers Trust
Pages 11, 23

Ernest C. Withers
*Rev. Ralph Abernathy Embracing
Rosa Parks, Benjamin Hooks
on Left, Southern Christian
Leadership Conference
Convention, Memphis, Tennessee*,
July 1968
gelatin silver print
H × W (Image and Sheet):
14 × 11 in. (35.6 × 27.9 cm)
2009.16.20
© Ernest C. Withers Trust
Page 76

Ernest C. Withers
*Sanitation Workers Assemble
in front of Clayborn Temple for
a Solidarity March. Memphis,
Tennessee*, March 29, 1968
gelatin silver print
H × W (Image and Sheet):
15¹⁵⁄₁₆ × 19¹³⁄₁₆ in. (40.5 × 50.3 cm)
2009.16.9
© Ernest C. Withers Trust
Page 69

Ernest C. Withers
*"Tent City" Family, Fayette
County, Tennessee*, 1960
gelatin silver print
H × W (Image and Sheet):
20 × 16 in. (50.8 × 40.6 cm)
2009.16.4
© Ernest C. Withers Trust
Page 20

Ernest C. Withers
*William Edwin Jones Pushes
Daughter Renee Andrewnetta
Jones (8 Months Old) during
Protest March on Main St. in
Memphis, Tennessee*, August 1961
gelatin silver print
H × W (Image and Sheet):
20 × 16 in. (50.8 × 40.6 cm)
2009.16.3
© Ernest C. Withers Trust
Pages 16, 33

Ernest C. Withers
*Young Woman Receives Her
Voter Registration Card, Fayette
County, Tennessee*, 1960
gelatin silver print
H × W (Image and Sheet):
20 × 16 in. (50.8 × 40.6 cm)
2009.16.5
© Ernest C. Withers Trust
Page 21

Jan Yoors
*Untitled (Malcolm X at Michaux's
Bookstore—Looking Down)*, 1962;
printed December 2, 2010
digital print
H × W (Image and Sheet):
13¹⁵⁄₁₆ × 10⅞ in. (35.4 × 27.6 cm)
Courtesy of Yoors Family and
L. Parker Stephenson Gallery
2011.162.2
© 1965 Jan Yoors
Page 56